a book of postcards

GAL PALS

women's friendship
and association

COMPILED BY SUSAN SHARP

pomegranate artbooks
san francisco

Pomegranate Artbooks
Box 6099
Rohnert Park, CA 94927

Pomegranate Europe Ltd.
Fullbridge House, Fullbridge
Maldon, Essex CM9 4LE
England

ISBN 0-87654-907-5
Pomegranate Catalog No. A845

Pomegranate publishes books of
postcards on a wide range of subjects.
Please write to the publisher for more information.

Designed by Elizabeth Key
Printed in Korea

05 04 03 02 01 00 99 11 10 9 8 7

THE IMAGES WITHIN have preserved for posterity the accoutrements of a bygone era—the cars we drove, the fashions we wore, the equipment we used, the activities we engaged in some fifty years ago. Our focus here, however, goes beneath the trappings of the times to portray one of the great and enduring strengths of our culture: the resilient thread that weaves women together in a tapestry of lasting friendship.

This book of postcards presents thirty vintage portraits of "gal pals," everyday women and girls in the company of one another. Women everywhere will recognize their mothers and grandmothers, their sisters and daughters, their friends, and themselves in these evocative images captured by a variety of photographers, including such renowned masters as Marion Post Wolcott, Dorothea Lange, and Russell Lee. Drawn from the archives of the Prints and Photographs Division of the Library of Congress, most of these pictures are from the Farm Security Administration Collection—an extraordinary photographic documentation of American life made during the Depression and World War II. Together they comprise a visual celebration of the pleasures, complexities, and abiding comforts of female friendship.

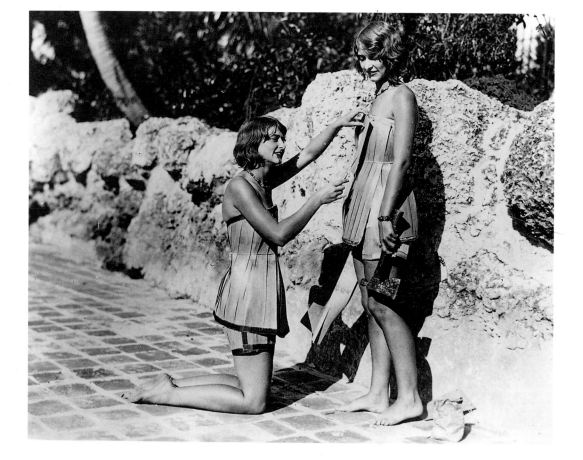

GAL PALS
women's friendship and association

Twins Ruth and Ruby Nolan in wooden bathing suits, Miami, Florida, c. 1941

POMEGRANATE BOX 6099 ROHNERT PARK, CA 94927

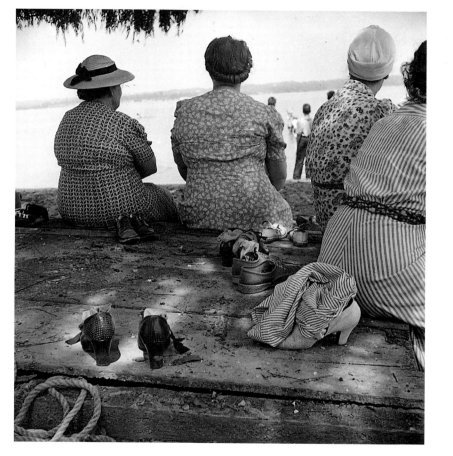

GAL PALS
women's friendship and association

Church members at a Sunday baptism near Mechanicsville, Maryland, c. 1942
Photograph by Marjory Collins

POMEGRANATE BOX 6099 ROHNERT PARK CA 94927

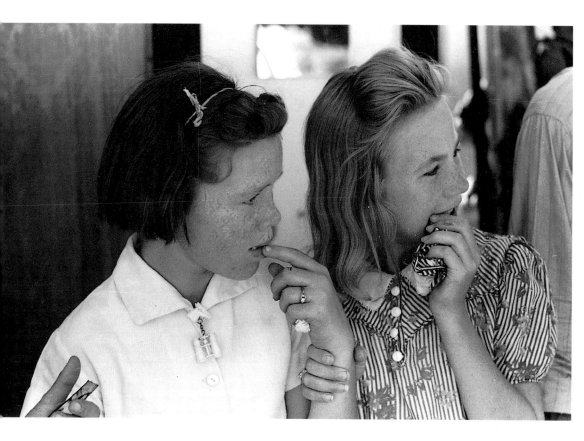

GAL PALS
women's friendship and association

Girls watching a greased pig race at a fair, Vale, Oregon, 1941
Photograph by Russell Lee

POMEGRANATE BOX 6099 ROHNERT PARK CA 94927

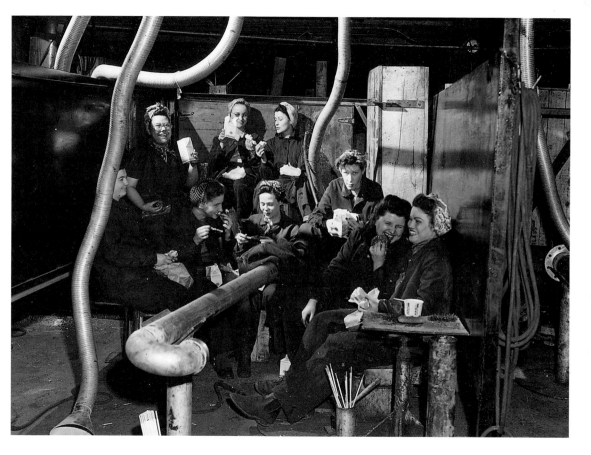

GAL PALS
women's friendship and association

Arc welders lunching in the pipe shop, Bethlehem-Fairfield shipyards,
Baltimore, Maryland, 1943
Photograph by Arthur Siegel

POMEGRANATE BOX 6099 ROHNERT PARK CA 94927

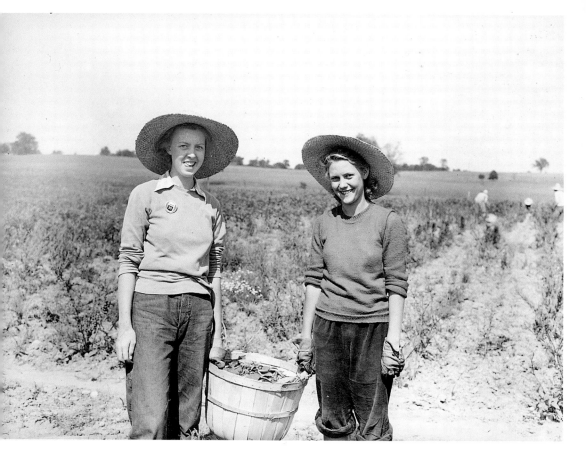

GAL PALS
women's friendship and association

Girls harvesting medicinal plants, Detroit, Michigan, 1943
Photograph by Russell Lee

POMEGRANATE BOX 6099 ROHNERT PARK CA 94927

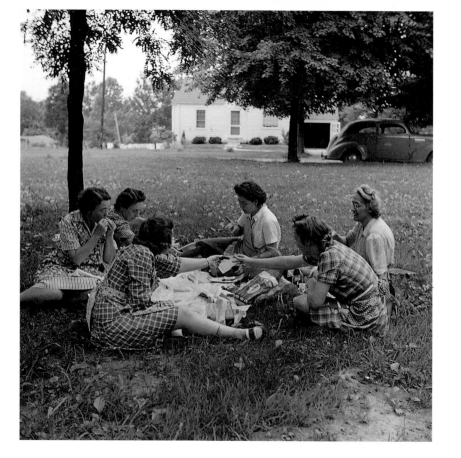

GAL PALS
women's friendship and association

A picnic at the community cannery, Jeffersontown, Kentucky, 1943
Photograph by Howard Hollem

POMEGRANATE BOX 6099 ROHNERT PARK, CA 94927

Prints and Photographs Division, Library of Congress

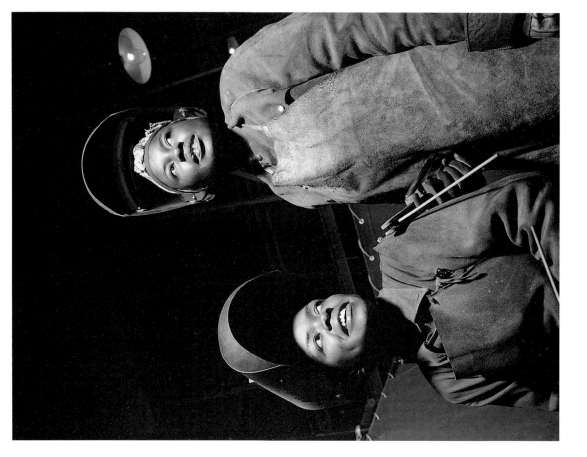

GAL PALS
women's friendship and association

Welders at the Landers, Frary, and Clark plant, New Britain,
Connecticut, 1943
Photograph by Gordon Parks

POMEGRANATE BOX 6099 ROHNERT PARK CA 94927

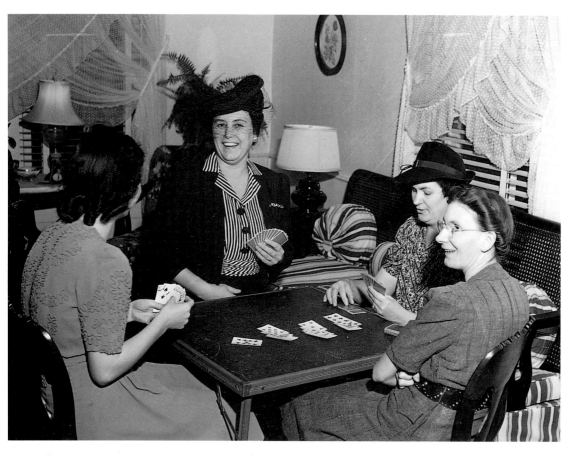

GAL PALS
women's friendship and association

The White Plains Bridge Club, Greene County, Georgia, 1941
Photograph by Jack Delano

POMEGRANATE BOX 6099 ROHNERT PARK CA 94927

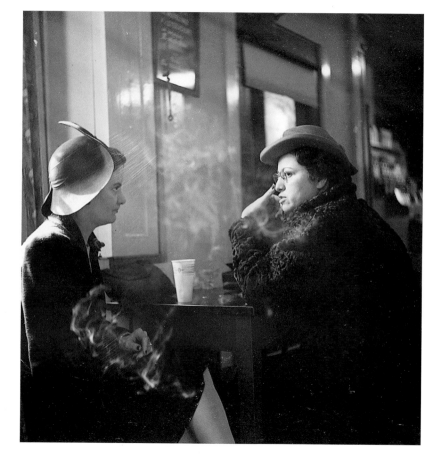

GAL PALS
women's friendship and association

Women taking a break at the neighborhood drugstore,
Washington, D.C., 1943
Photograph by Esther Bubley

POMEGRANATE ⸱ BOX 6099 ⸱ ROHNERT PARK CA 94927

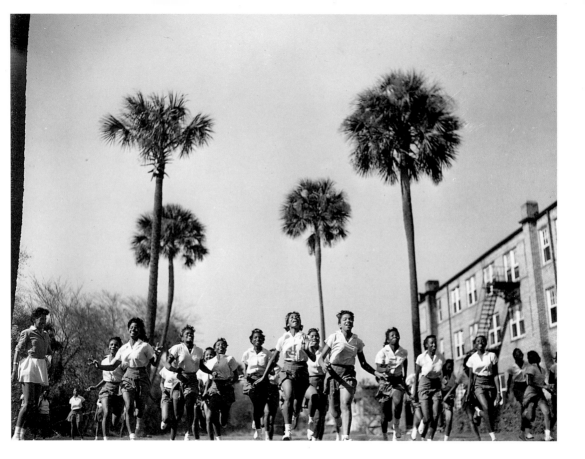

GAL PALS
women's friendship and association

Physical education class, Bethune-Cookman College,
Daytona Beach, Florida, 1943
Photograph by Gordon Parks

POMEGRANATE BOX 6099 ROHNERT PARK CA 94927

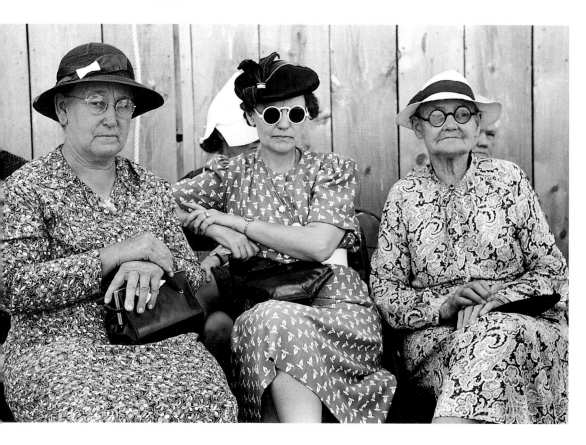

GAL PALS
women's friendship and association

Friends at the 4-H Club fair, Cimarron, Kansas, 1939
Photograph by Russell Lee

POMEGRANATE BOX 6099 ROHNERT PARK CA 94927

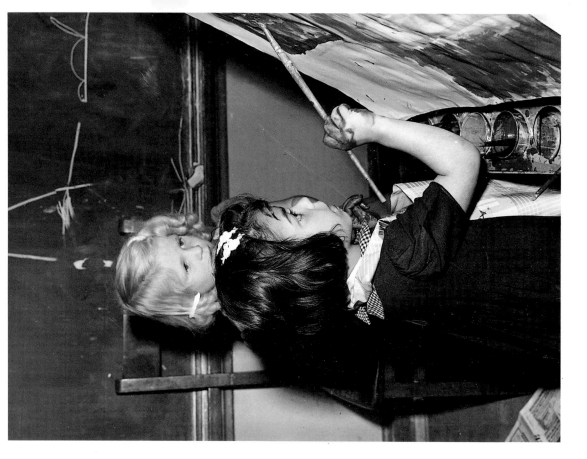

GAL PALS
women's friendship and association

Kindergarten classmates, San Leandro, California, 1942
Photograph by Russell Lee

POMEGRANATE BOX 6099 ROHNERT PARK CA 94927

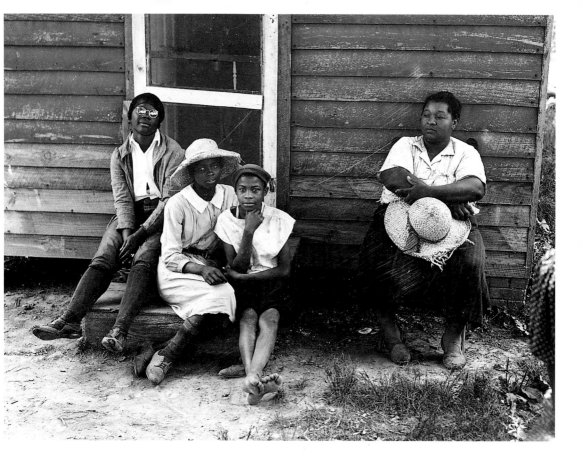

GAL PALS
women's friendship and association

Tomato pickers, Westover, Maryland, 1940
Photograph by Jack Delano

POMEGRANATE BOX 6099 ROHNERT PARK CA 94927

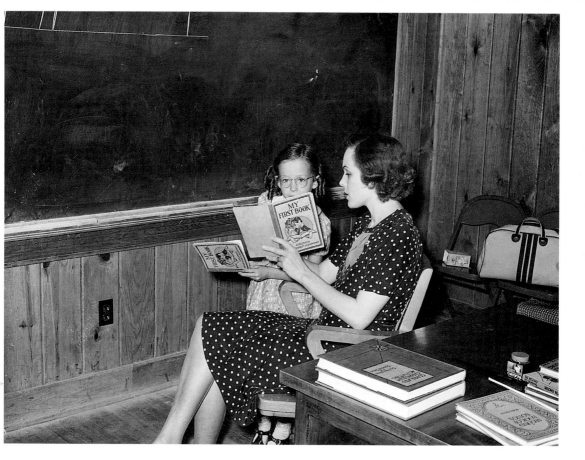

GAL PALS
women's friendship and association

Reading lesson at a farm workers' community school, Woodville,
California, 1942

POMEGRANATE BOX 6099 ROHNERT PARK CA 94927

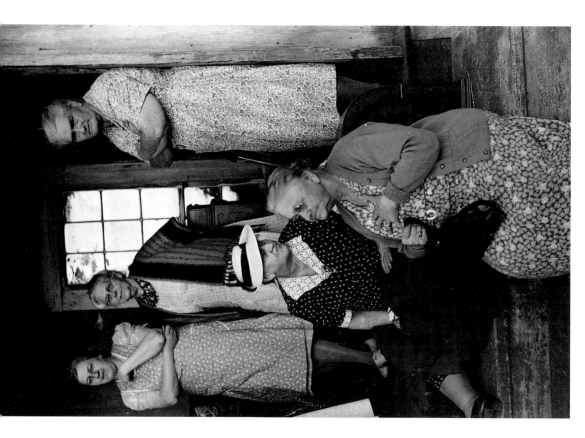

GAL PALS
women's friendship and association

Spectators at an auction, East Albany, Vermont, 1941
Photograph by Jack Delano

POMEGRANATE BOX 6099 ROHNERT PARK CA 94927

Prints and Photographs Division, Library of Congress

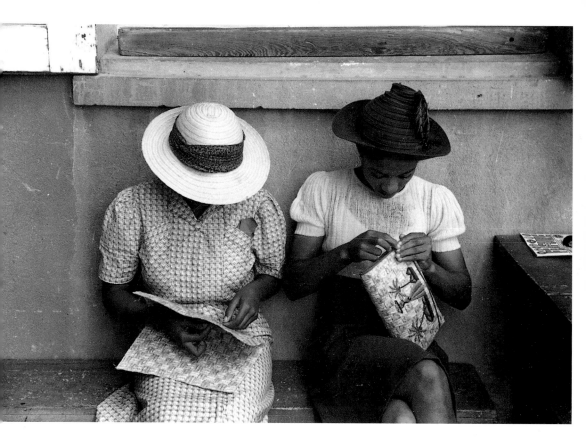

GAL PALS
women's friendship and association

Women working on handbags at a handicrafts cooperative,
St. Thomas Island, Virgin Islands, 1941
Photograph by Jack Delano

POMEGRANATE BOX 6099 ROHNERT PARK CA 94927

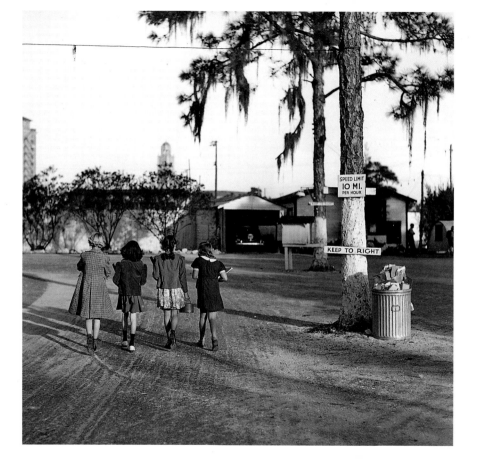

GAL PALS
women's friendship and association

Girls leaving their trailer park on their way to school, Sarasota, Florida, 1941
Photograph by Marion Post Wolcott

POMEGRANATE BOX 6099 ROHNERT PARK, CA 94927

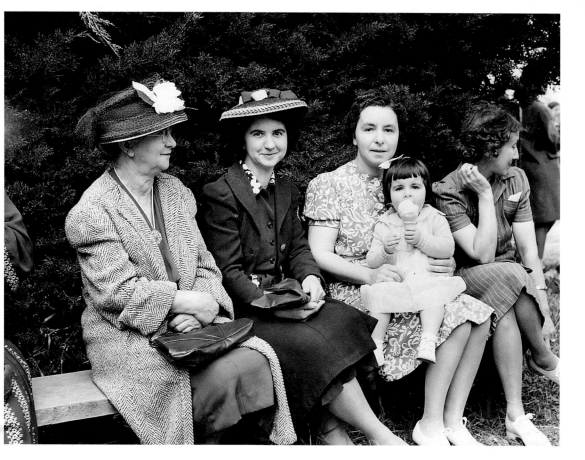

GAL PALS
women's friendship and association

Portuguese Americans at the Festival of the Holy Ghost,
Petaluma, California, 1942
Photograph by Russell Lee

POMEGRANATE BOX 6099 ROHNERT PARK CA 94927

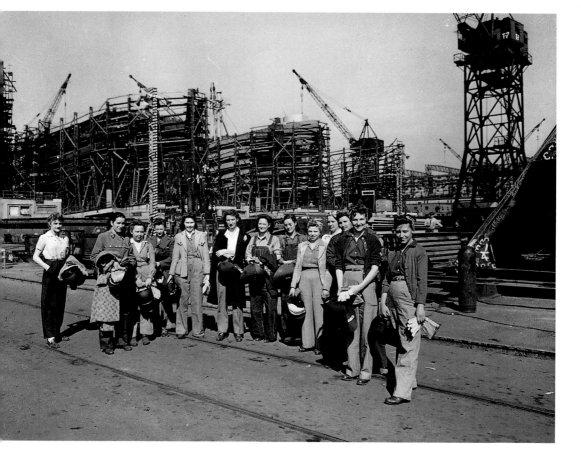

GAL PALS
women's friendship and association

Arc welder trainees, Bethlehem-Fairfield shipyards,
Baltimore, Maryland, 1943
Photograph by Arthur Siegel

POMEGRANATE BOX 6099 ROHNERT PARK CA 94927

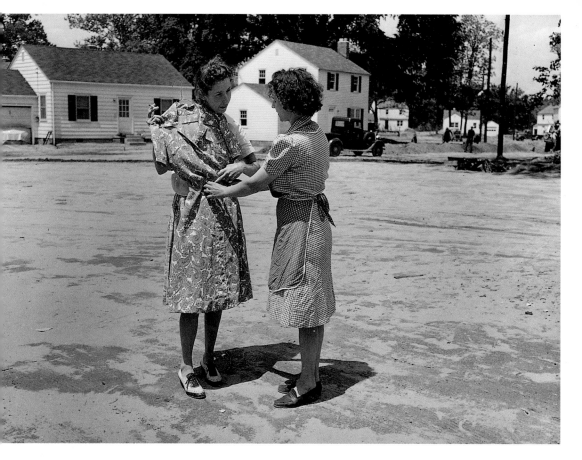

GAL PALS
women's friendship and association

Neighbors discussing a sewing project, Point Pleasant,
West Virginia, 1943
Photograph by Arthur Siegel

POMEGRANATE BOX 6099 ROHNERT PARK CA 94927

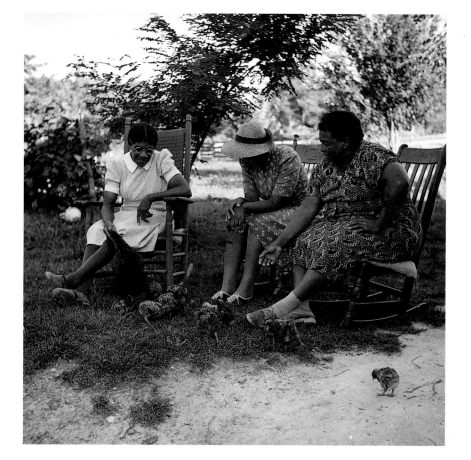

GAL PALS
women's friendship and association

Farm Security Administration workers and client discussing household
affairs, St. Mary's County, Maryland, 1941
Photograph by John Collier

POMEGRANATE BOX 6099 ROHNERT PARK CA 94927